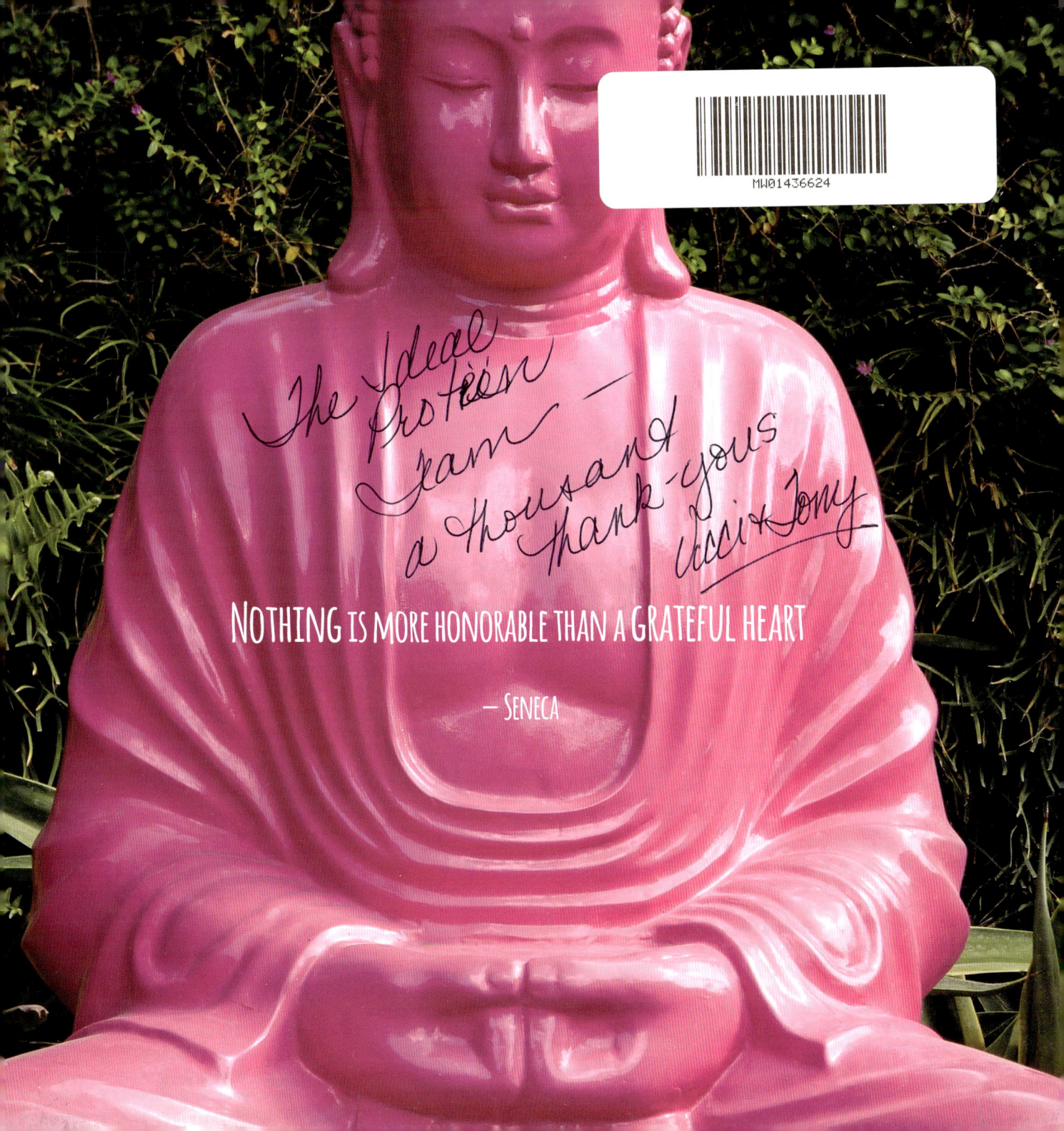

Creatrix is a way of Being: heart-centred, passionate, grateful, uniquely yourself, in the moment... connected. I call it *"living cre.actively"*. Come and play. www.thecreatrix.co.nz

Copyright © Creatrix Ltd 2014

All rights reserved. No part of this publication may be reproduced or transmitted or utilised in any form, or by any means, electronic, mechanical, photocopying or otherwise without the prior written permission of the publisher.

Design and Layout by Melanie G Mason
Photographs © Melanie G Mason

Cover Design and Photograph © Melanie G Mason;
Holy Water — Mother Temple of Besakih, Bali
Miniatures: Bali, Courchevel, Courchevel, Singapore, Bali, Trinidad & Tobago, Fiji

ISBN 978-0-473-24222-0

Printed on plantation grown, chlorine free paper.

DISCLAIMER

Creatrix Publishing is grateful for permission to reproduce copyright material. While every reasonable effort has been made to clear copyright and properly acknowledge the sources, writers, and poets, we apologise for any omissions that may have been made. If an omission has occurred please email melanie@thecreatrix.co.nz and it can be included or rectified in subsequent printings.

Blessing with blue hands — Singapore

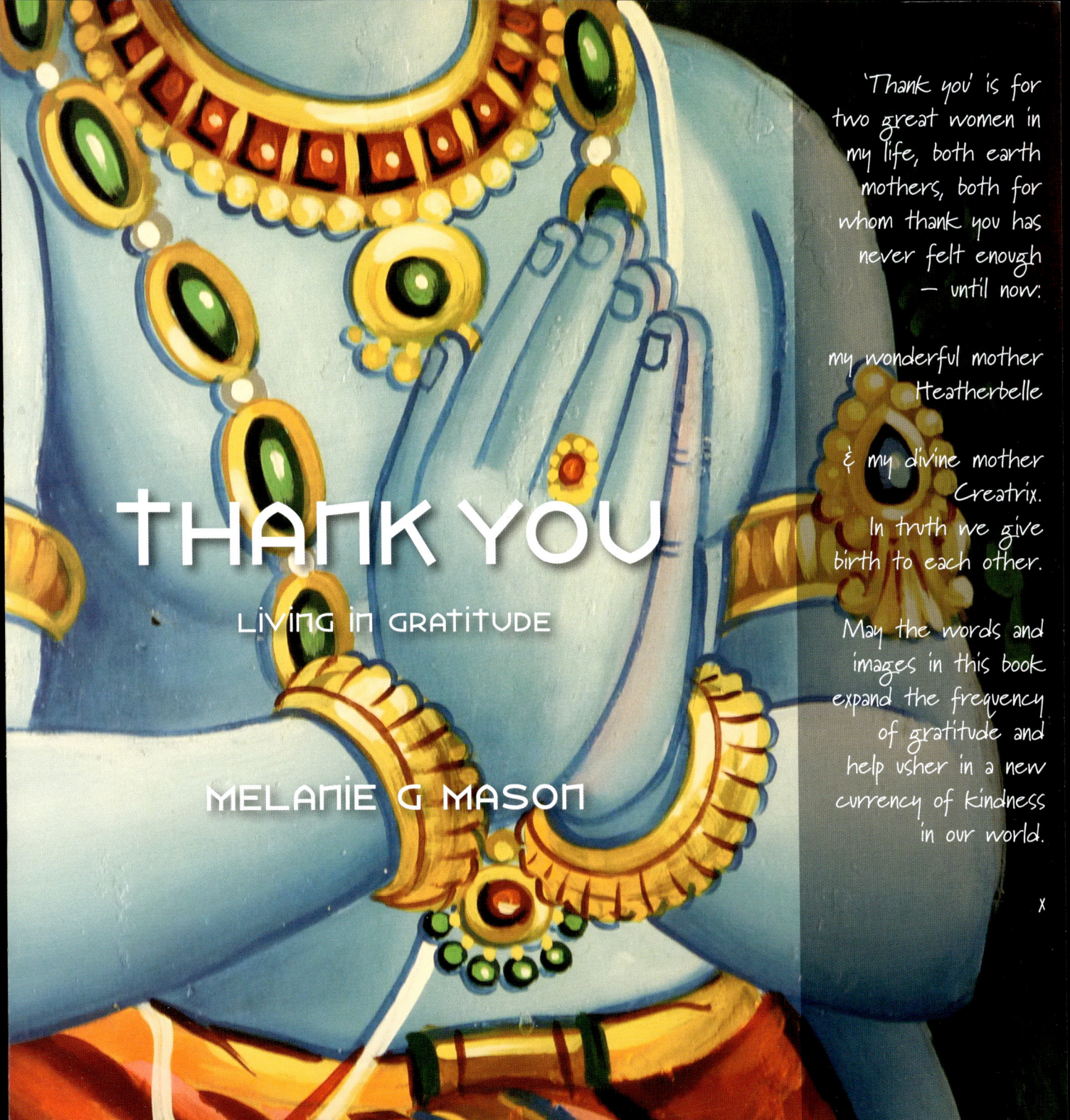

Thank You

living in gratitude

Melanie G Mason

'Thank you' is for two great women in my life, both earth mothers, both for whom thank you has never felt enough — until now:

my wonderful mother Heatherbelle

& my divine mother Creatrix.
In truth we give birth to each other.

May the words and images in this book expand the frequency of gratitude and help usher in a new currency of kindness in our world.

x

THANK YOU

I'm here to start a conversation with you... I want to talk about 'thank you'. But I don't want us to just talk about it. Instead, let's live inside it, let's taste it, and breathe it in. Let's play with it and learn from it! If we are willing to immerse ourselves in thanks, we can join the world in gratitude.

ETERNAL

I'd be surprised if you hadn't already heard about the value of a thank you – the message is older than memory and its value has been appreciated across the centuries. More than 2000 years ago Roman philosopher and statesman Cicero said "a thankful heart was not only the greatest virtue but the parent of all the others". While 700 years ago German philosopher and mystic Meister Eckhart said "If you say one prayer your whole life, 'thank you' will suffice". From the east we've learned to appreciate life's simple pleasures, while in the west we've practised counting our blessings, many of us since Sunday school days. Practising gratitude has increasingly become regarded as one of the cornerstones of living a happy and fulfilling life, and is now a current topic of scientific research.

CONNECTION

When we say thank you and really mean it, we are acknowledging and celebrating a moment of connection that is felt beyond words and treasured in the timelessness of our hearts. Saying thank you and feeling gratitude changes our frequency into a more expansive state. All we have to do is shift our attention from seeking thanks to feeling thankful and expressing gratitude. The more we give thanks, the more gratitude we feel, and the more acts of kindness we create.

PEACE-MAKING

When we are in a state of thankfulness we are more creative, physically healthier, more harmonious in our home, work and community environments. Thankfulness improves our character and supports our spiritual growth; our relationships improve; and we are more appreciative of the goodness in the world and the gifts that surround us every day. Gratitude is an empowering step towards mindfulness and has the potential to bring deep peace to our daily lives.

BENEFITS

- **POSITIVE EMOTIONS:** Giving thanks makes us happier, more joyful, and more optimistic. That's because what we focus on expands. Therefore when we focus on something good, the goodness is magnified.
- **INNER STRENGTH:** Finding things to be grateful for makes us more resilient, enabling us to cope better with the ups and downs of daily living.
- **BETTER FRIENDSHIPS:** Practising gratitude strengthens our relationships, and it reduces loneliness and isolation. The connecting fibres of our relationships become stronger and more positive. We are more generous, caring and compassionate.
- **IMPROVED HEALTH:** Having an attitude of gratitude reduces stress and improves health; it strengthens our immune systems and lowers blood pressure.
- **IN THE MOMENT:** Being thankful shifts our focus from what we haven't got to what is already here. It means accepting what is, and that enables us to live more fully in the present moment.

WHERE TO BEGIN

Read, laugh and cry with me through my 'private' thank you letters; there is one in each chapter. I've written them to ex-partners, parents, friends, body-parts, moments in time, and a younger version of myself. *I invite you to write your own!* You can begin with just one word.

Take up the challenges in the *'Staying Grateful'* pages. Play with the ideas; practise the ones that tug at your attention. Feel what fits for you, simply leave what doesn't and keep what you love. I hope you have fun with it! Get inspired, get courageous and get creative about thank you in your own life! In doing so you join the world in a collective consciousness of gratitude.

I truly believe that one word can change the world. It starts with each of us becoming more aware of what we already have, and creating our own culture of kindness where we are willing to say thanks to the people around us everyday for what we love and appreciate.

Melanie

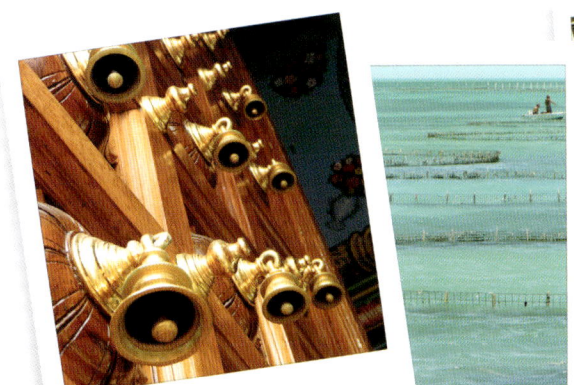

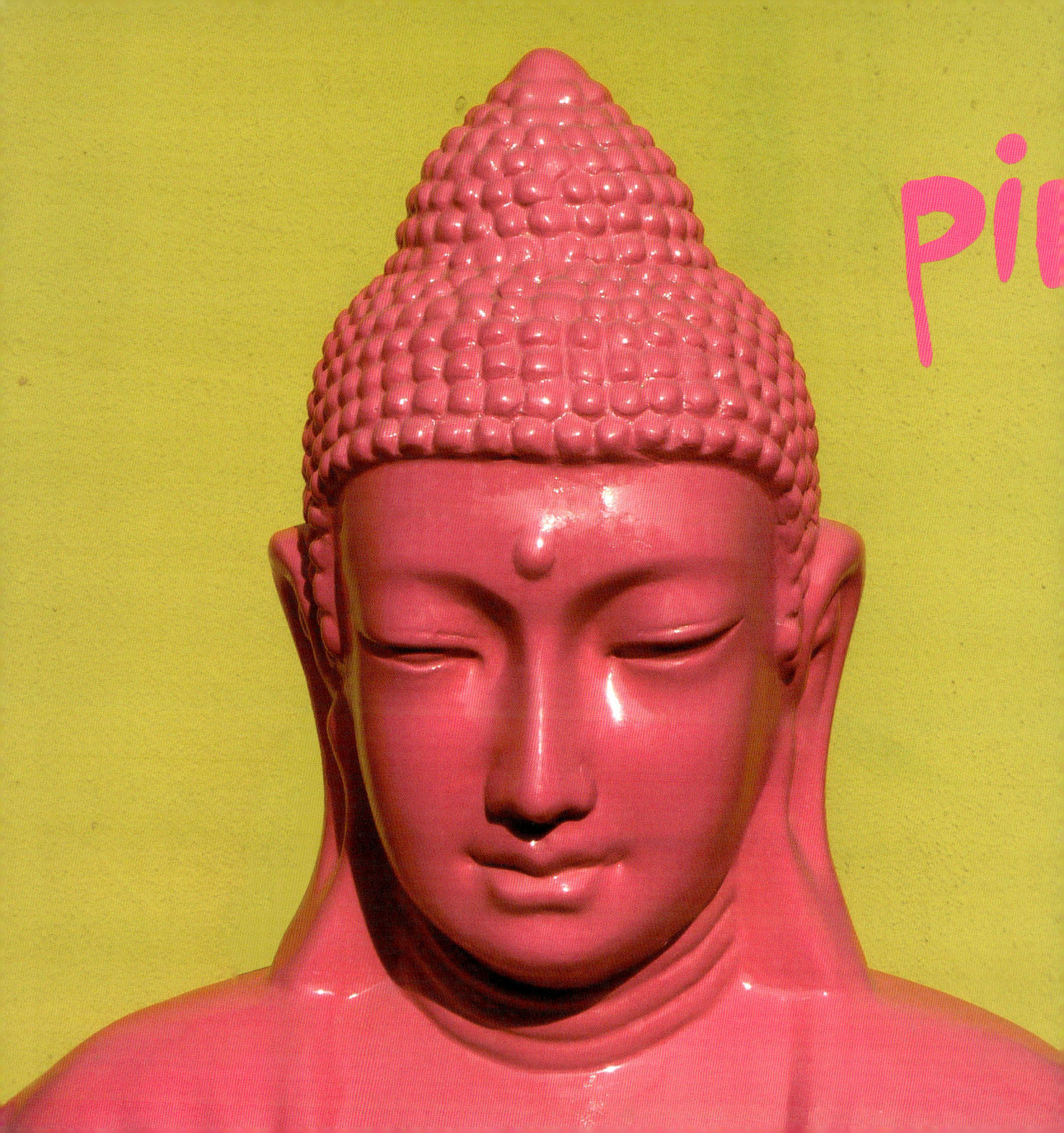

ky PRETTY PINK PINK

Pink is an unusual colour; a curious mix of red and white, passion and purity. A dab of pink in a room or a splash of it in conversation can colour a passing moment with delight.

Pink can be soft like pale rose petals and Turkish delight. It can be magenta-hot like bougainvillea blazing on a Greek wall.

Sip a pink champagne, dissolve a wisp of candy floss on your tongue, listen to a song by Pink, or watch an old Pink Panther movie. Have someone turn pink with delight over an outrageous but fitting compliment.

Get in the pink today!

Hot pink happy Buddha – Seminyak, Bali, Indonesia

One can pay back the loan of gold,
but one dies forever in debt
to those who are kind

[Malayan proverb]

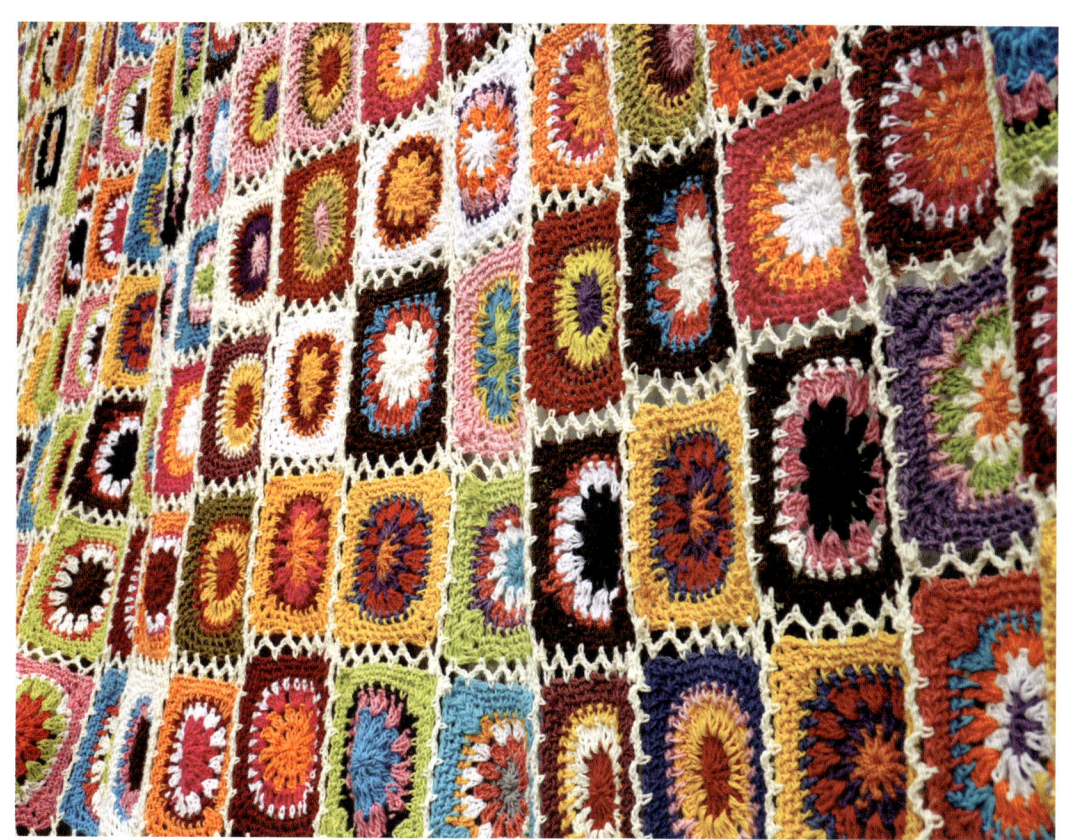

Grandma crocheted a rug — Ubud, Bali

IF YOU SAY
ONE PRAYER
YOUR WHOLE LIFE
THANK YOU
WILL SUFFICE

— MEISTER ECKHART

Moroccan tea by candlelight – Le Jas de L'ange, Eygalières, France

Dear X

thanks for the roses, X quisite

thanks for your enthusiasm, X uberant

thanks for your energy, X cessive

thanks for the trip to Colombia and Ecuador, X citing

thanks for heli-skiing, X hilarating

thanks for the lessons at work and at play, X pansive

thanks for our beautiful children, X traordinary

thanks for finally telling the truth, X cruciating

thanks for the therapy, X pensive

thanks for settling, X hausting

thanks for leaving, Xxxxxx

thank you note #33:
to an ex

It was the 80s; big shoulders, big hair — and a big bouquet to begin our relationship

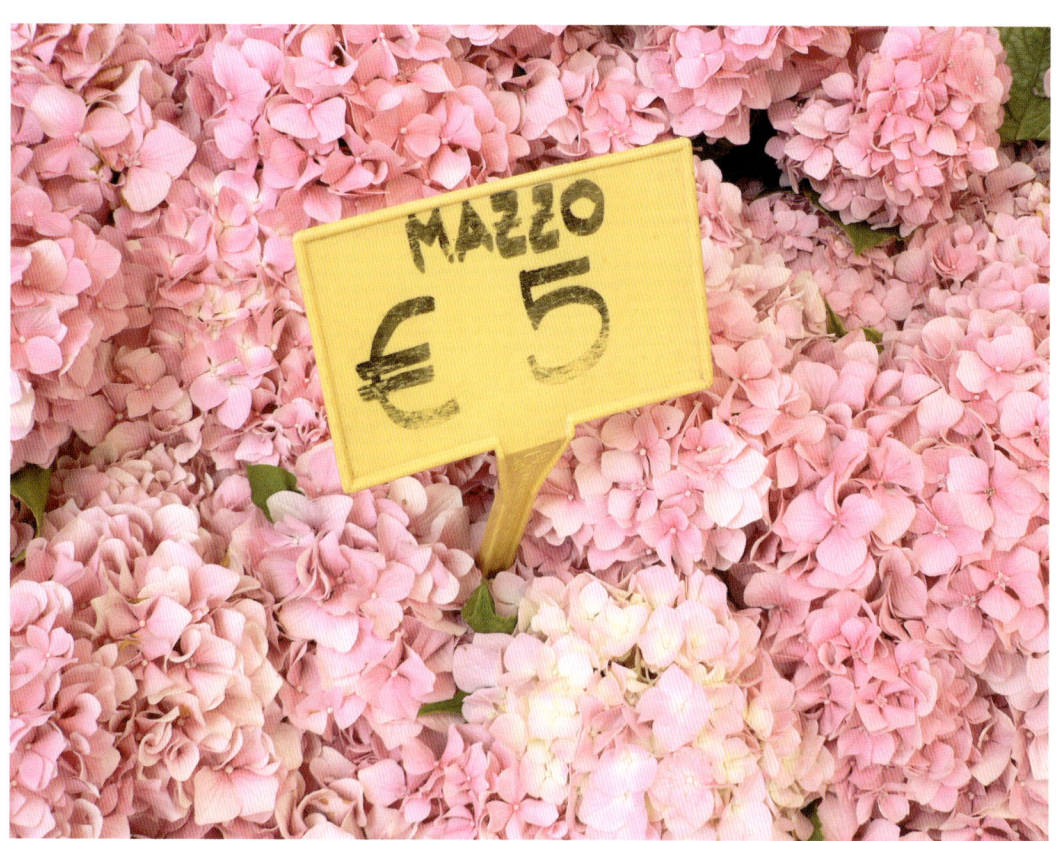

Pink hydrangeas — Venice, Italy

Let us be grateful
to the people who make
us happy;
they are the
charming gardeners who
make our souls blossom

—Marcel Proust

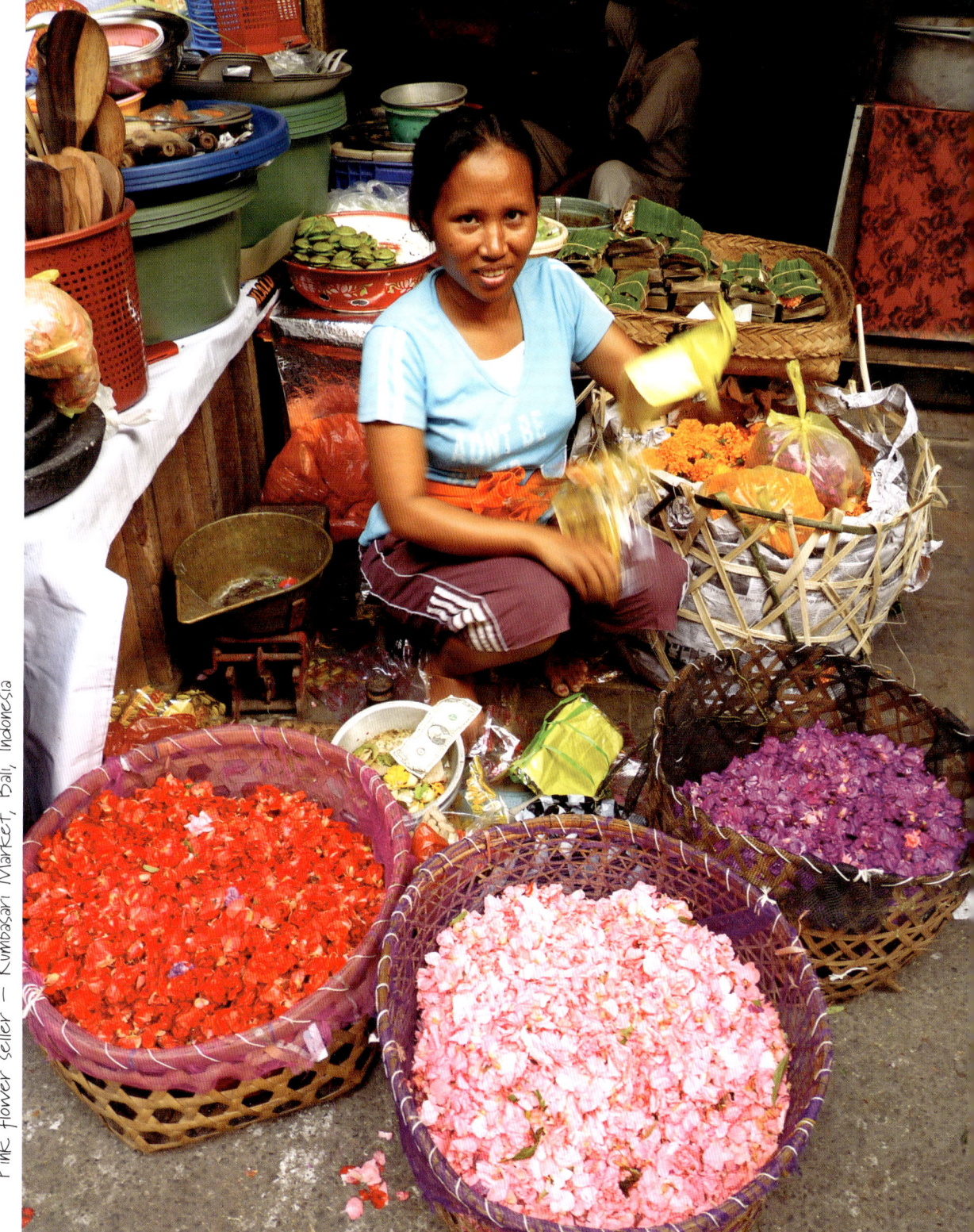
Pink flower seller — Kumbasari Market, Bali, Indonesia

No duty is more urgent than that of returning thanks

(unknown)

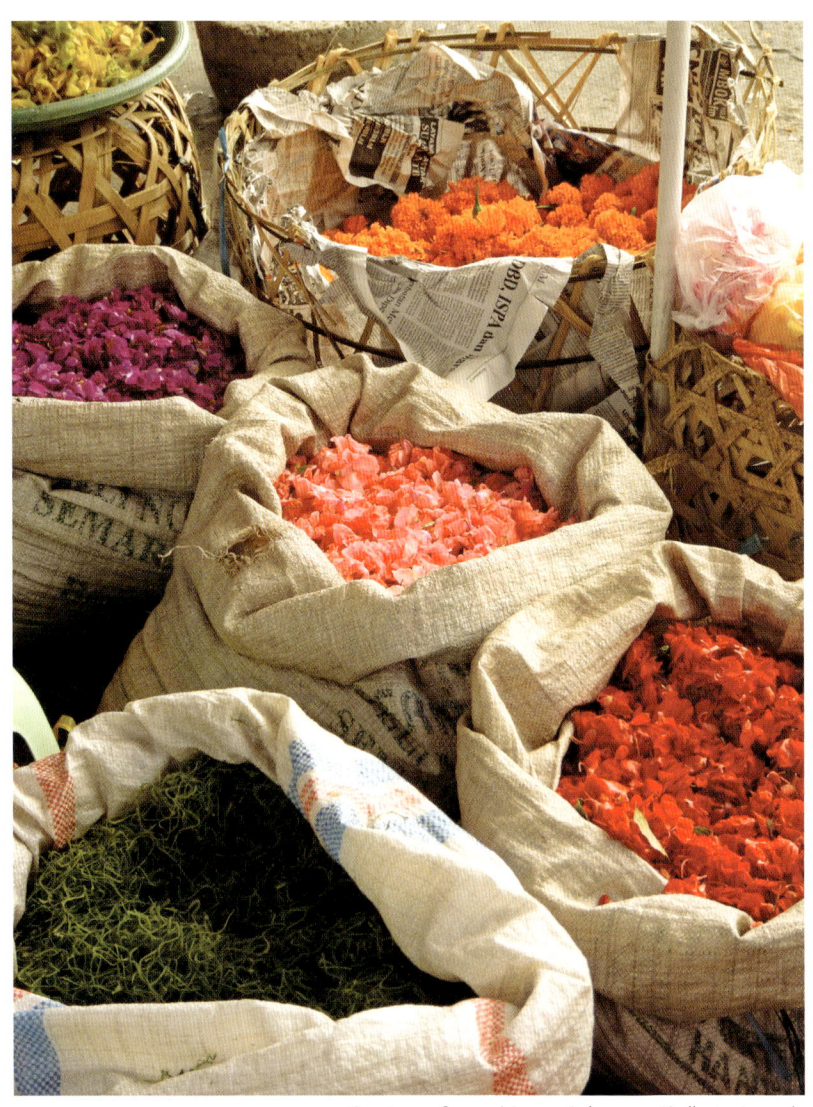

Sacks of pretty petals — Bali, Indonesia

Staying Grateful # 1; Keep a Gratitude Journal

Keeping a gratitude journal is a powerful way to bring your attention to what is good. Just thinking about the blessings in our lives changes the frequency of our thoughts to a more positive and optimistic state of being.

Start by writing down three things you are grateful for on a daily or weekly basis. It doesn't matter how you do it, in list form or poetic prose. It doesn't matter when you do it, first thing in the morning or last thing at night. The important thing is to get started wherever you are – even if the only thing on your list is 'nothing bad happened today'. Start cataloguing the things you appreciate and truly savour each of these items as a little gift in your life.

Starting a thank you journal is a bit like planting a flower garden – gradually your life will start to bloom and fill with the fragrance of appreciation

If you need a bit of a nudge getting started, ask yourself "What do I appreciate about my mind? My body? My family? My friends? My job? My home? Things that have happened to me? Things that haven't happened to me?"

Resist the urge to generalise and try and be as specific as possible. For example, when thinking about which friends you appreciate, consider the particular qualities you are most thankful for in each friend. It might be loyalty in one friend, or a sense of humour in another. Try reversing it and think about which of your own qualities you are thankful for with certain friends.

I imagine that 'thank you' is the only living thing
(after E.E. Cummings)

Life's travelling companions – my journals

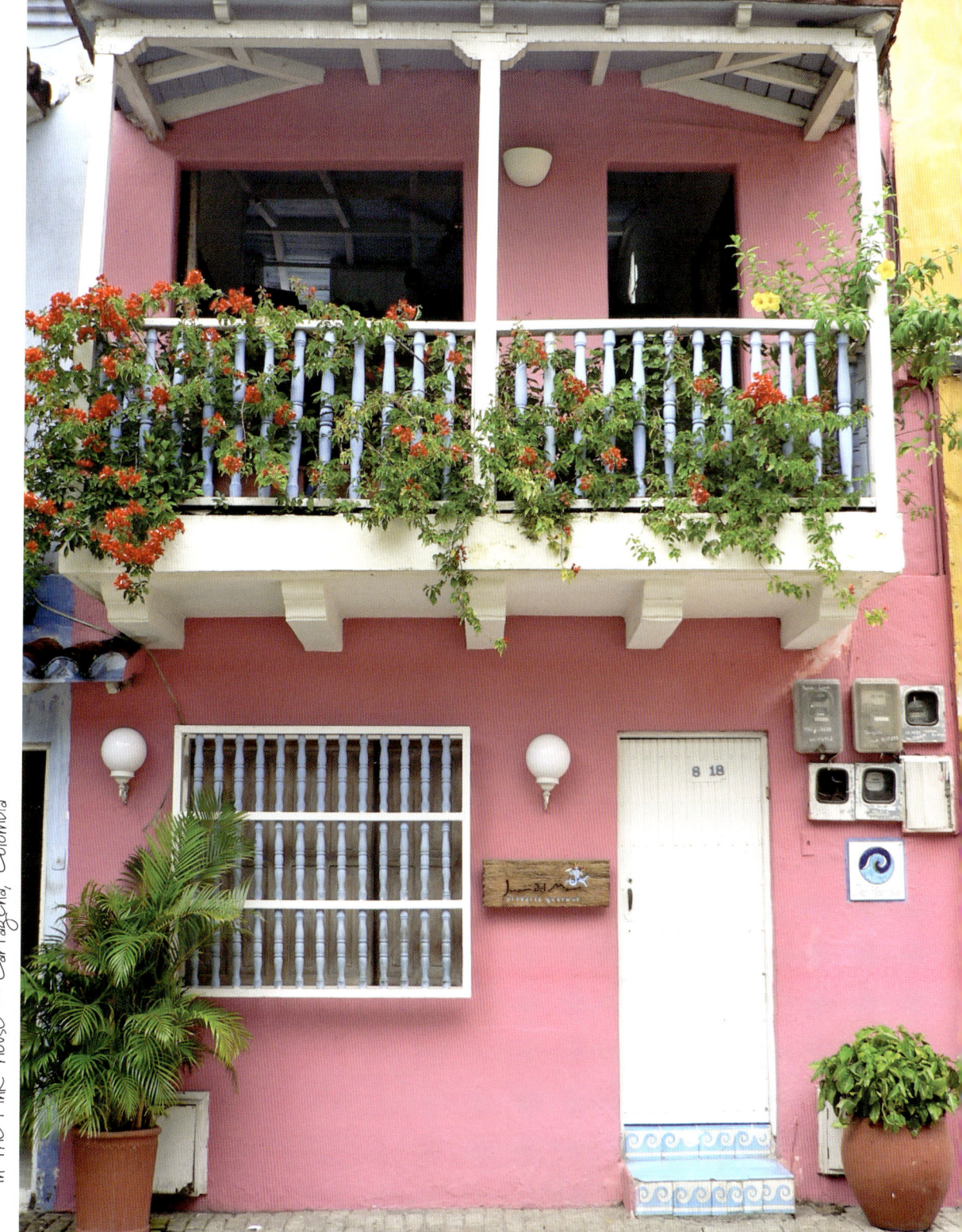

'In the Pink' house – Cartagena, Colombia

The world is so full of a number of things,
I'm sure we should all be as happy as kings.

—Robert Louis Stevenson

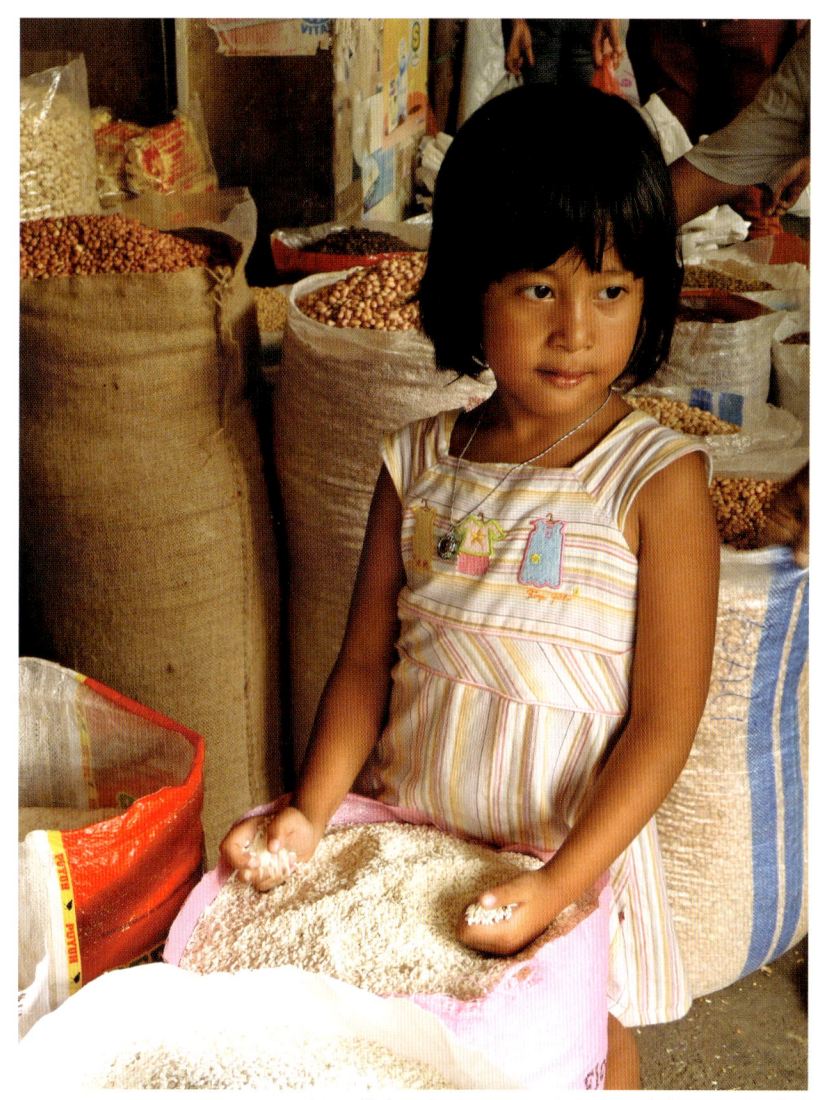

Handfuls of dreams — Kumbasari Market, Bali

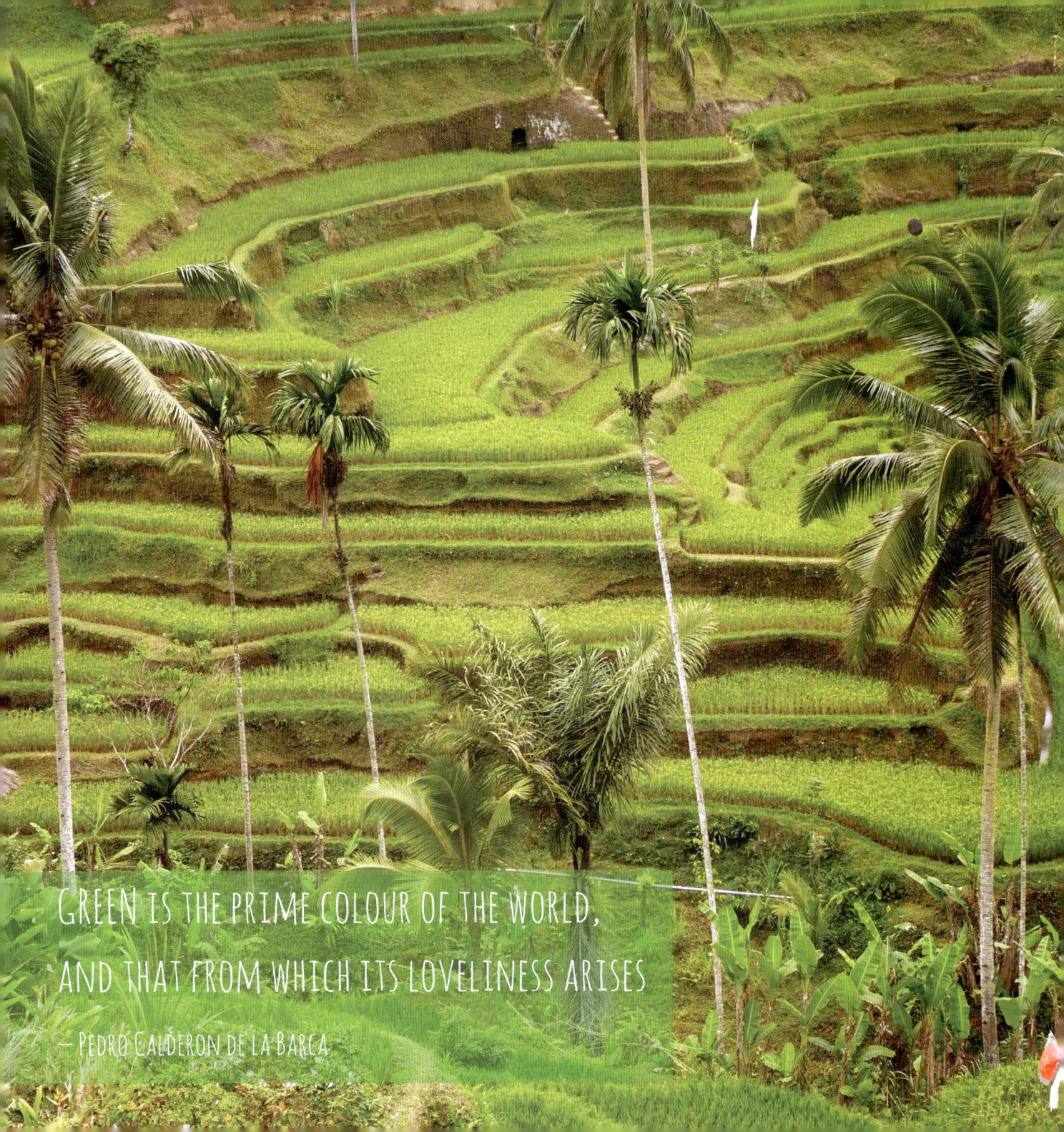

GREEN
LUSCIOUS

Fresh basil, wild mint, and the big outdoors-smell of new mown grass. Green is alive with youthful vitality and the wild fertile exuberance of springtime.

How green is your world? Your diet? Your environment? Your outlook? Green is more than a colour, it is a way of being. Go green and join the global shift in consciousness toward a more harmonious, sustainable and respectful existence with our precious planet. Appreciate the greens around you and sew some mental seeds towards a greener state of mind.

Rice terraces — Ubud, Bali, Indonesia

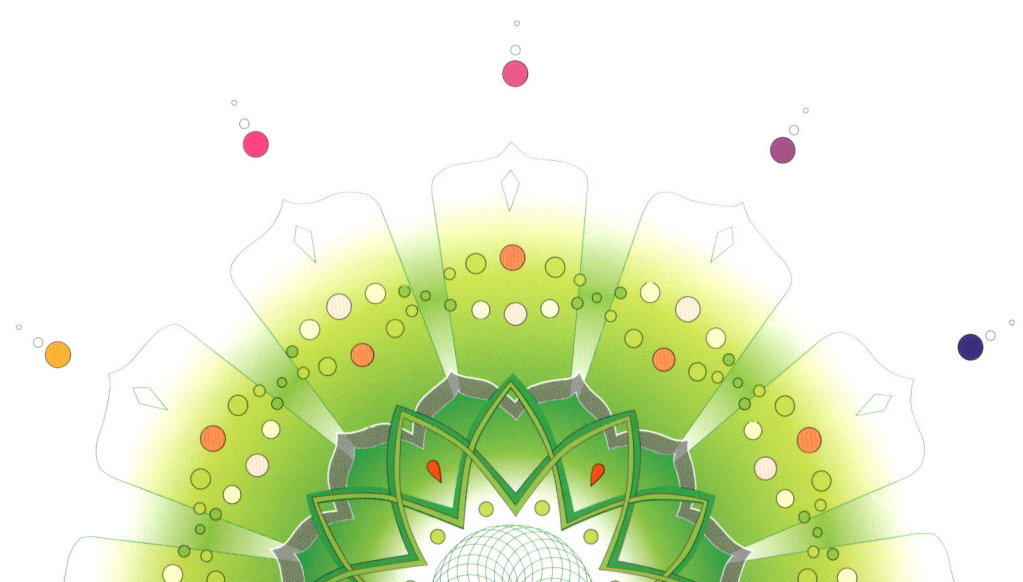

Delight in the Little Things

—Rudyard Kipling

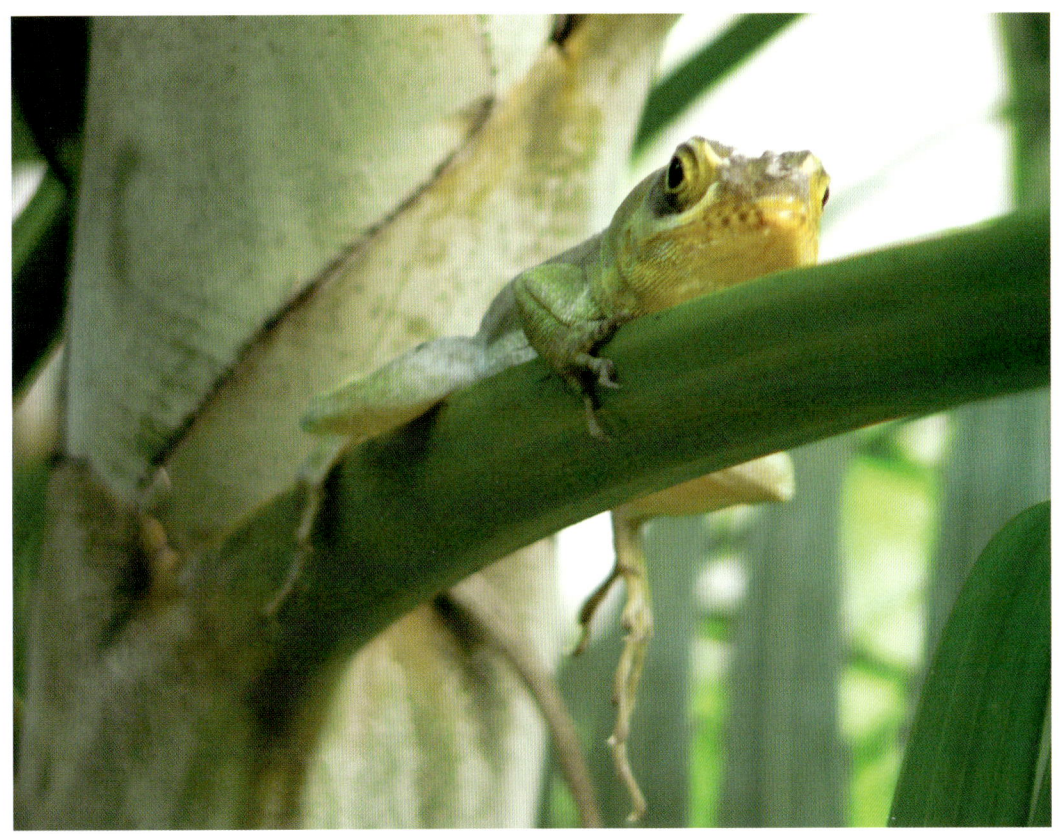

Frog friend — Trinidad & Tobago

Thank you for strange goo in pots
Thank you for the colours, lots
Lumpy textures, odors many
Thank you but I wont have any

Green goo — Kumbasari Market, Bali, Indonesia

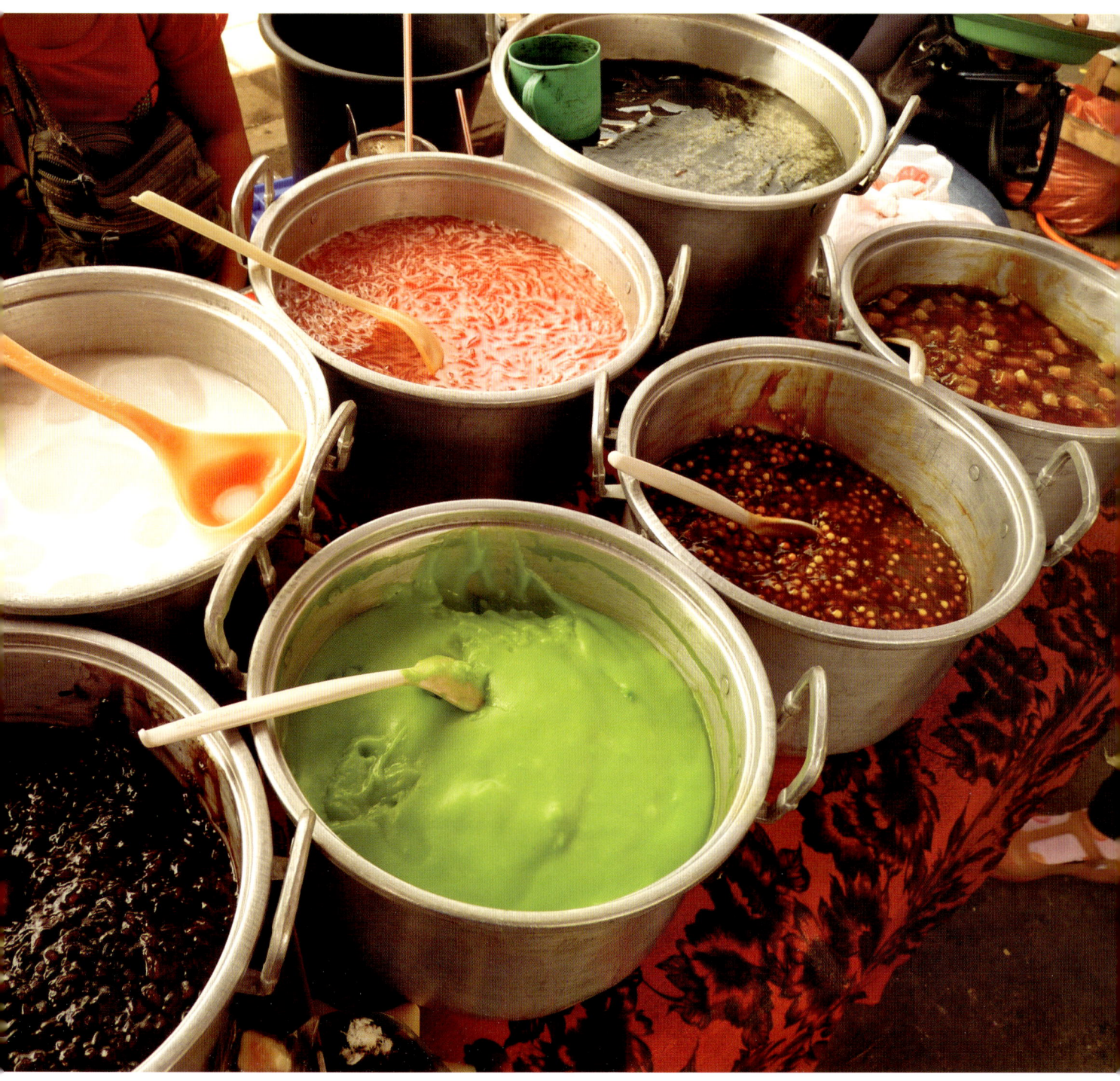

Mille Grazie

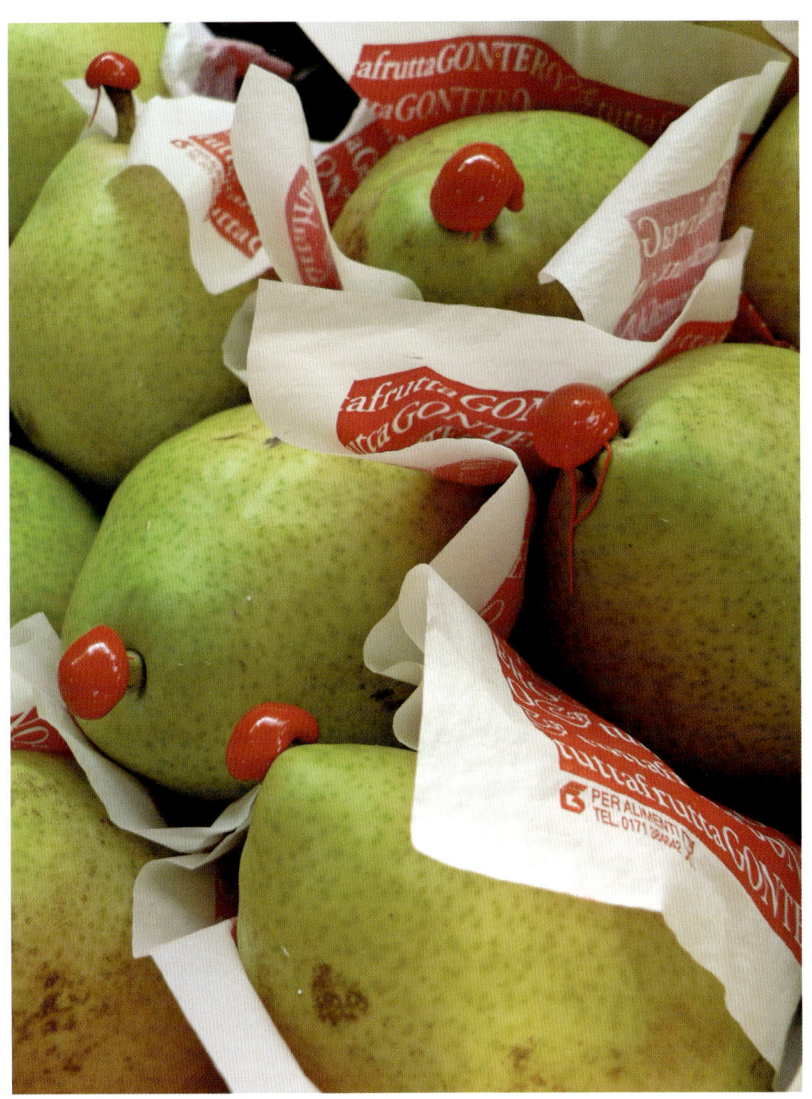

Artful pears — Venice, Italy

The deepest craving of human nature
is the need to be appreciated.

— William James

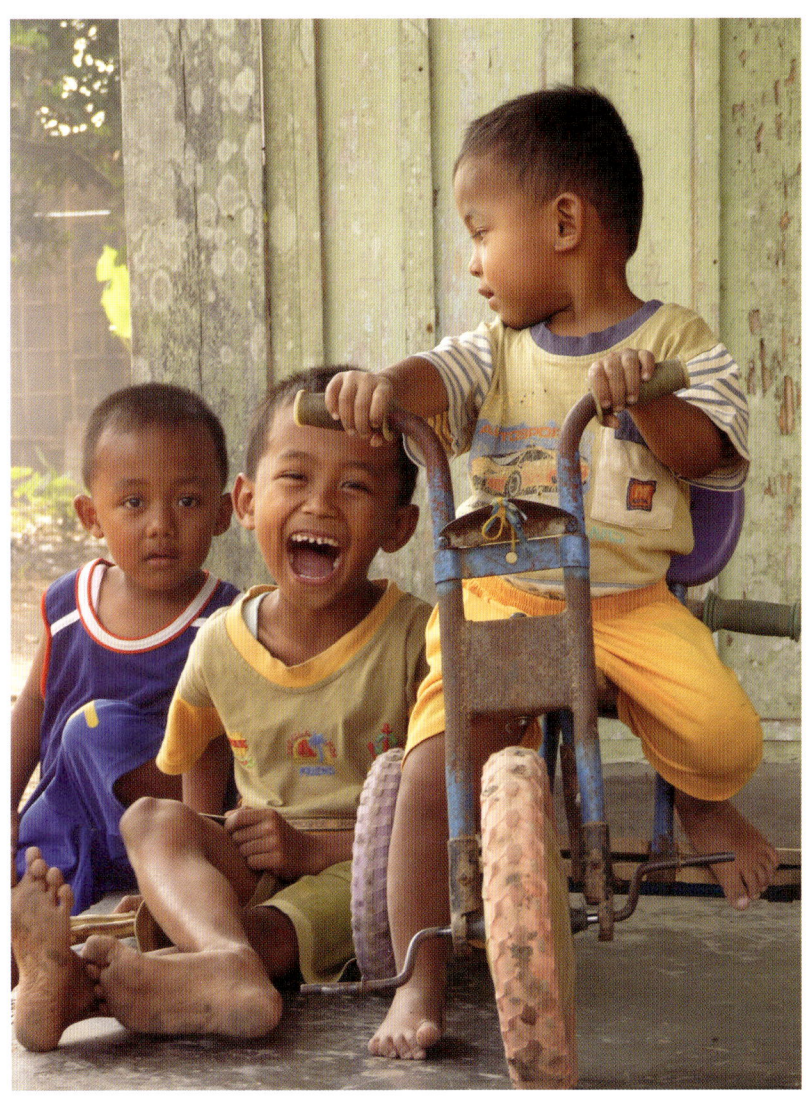

So funny — Tobacco fields, Java

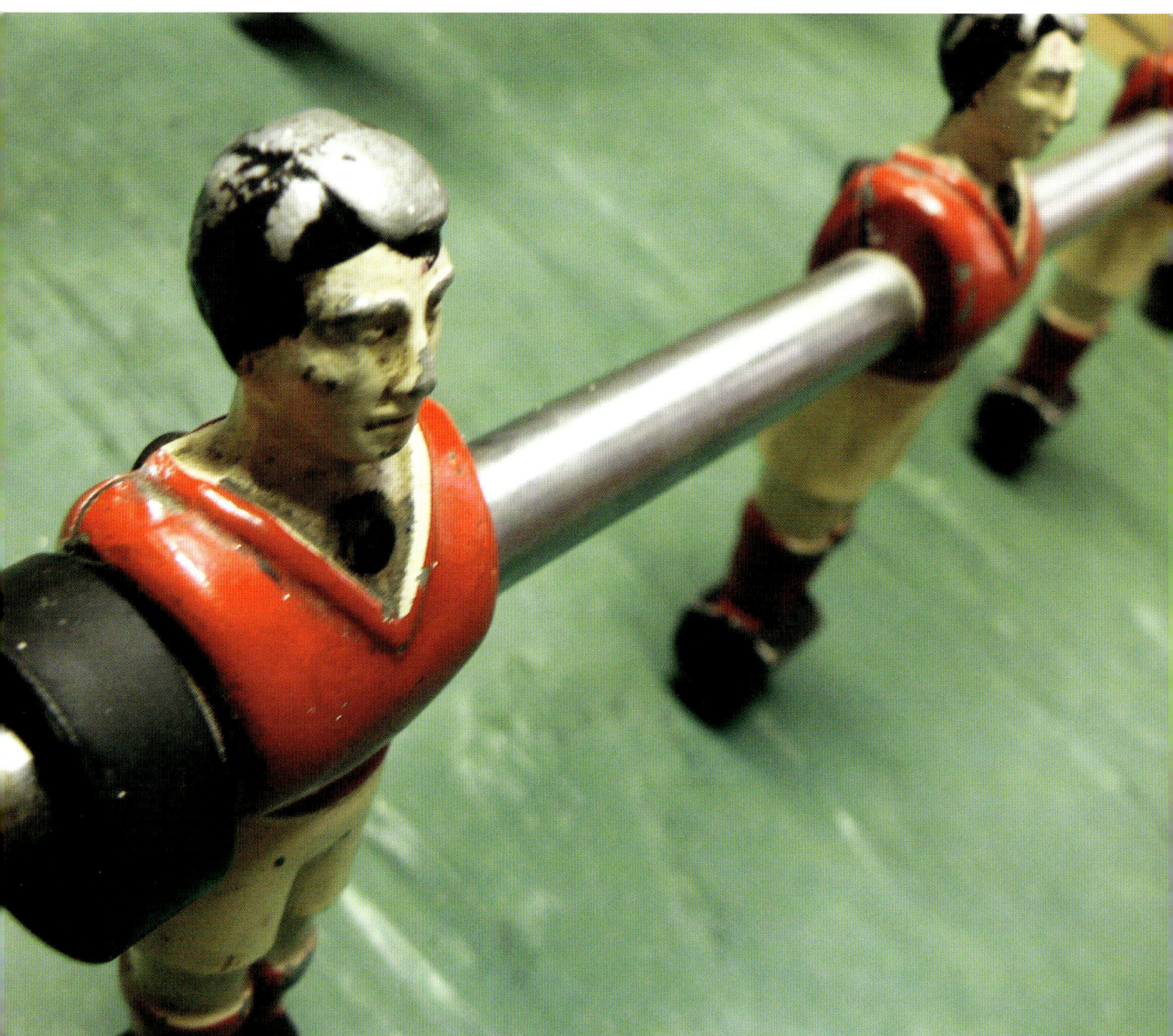

The projector fan hums. The slide-casing clicks left and right. Wide worlds of wonder open to my untravelled eyes.

Green gorges of inflatable rafts appear on the white block wall of our living room. Tall mountains of hard work slide past. Pulleys and parties. Those long, long skis you called Candy-bars with their 'rat-trap' bindings. Friendship and laughter echo through the years, among the well-told tales of building a ski-field and voyages to foreign lands.

Filled with fearless excitement and anticipation, I can barely wait for my own life to begin.

Thanks Dad

Thank you note #63; to my Dad

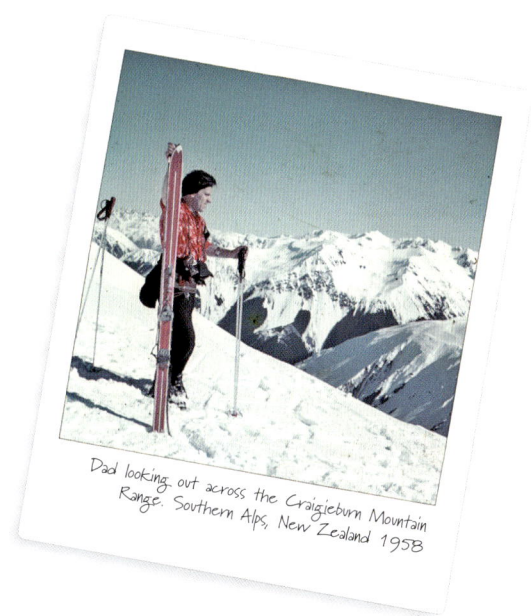

Dad looking out across the Craigieburn Mountain Range. Southern Alps, New Zealand 1958

Foosball table — Varages, France

The smallest act of kindness is worth more than the grandest intention

— Oscar Wilde

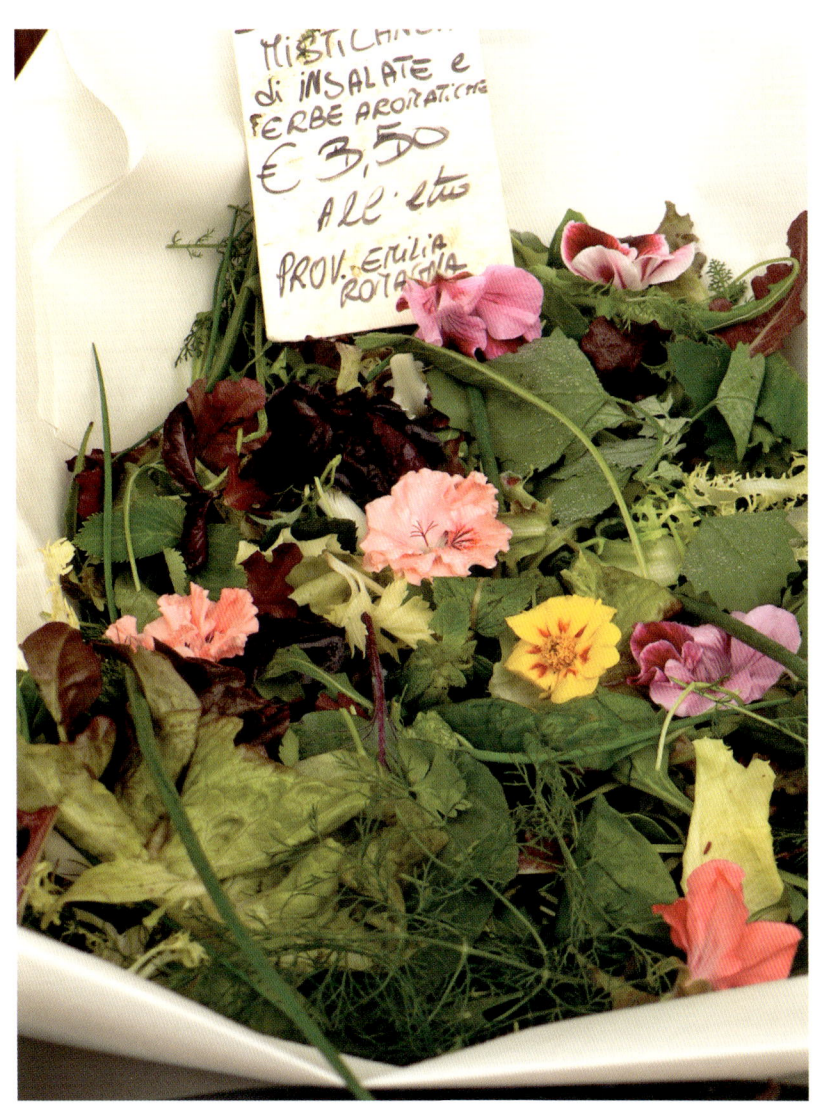

Green salad with flowers — Venice, Italy

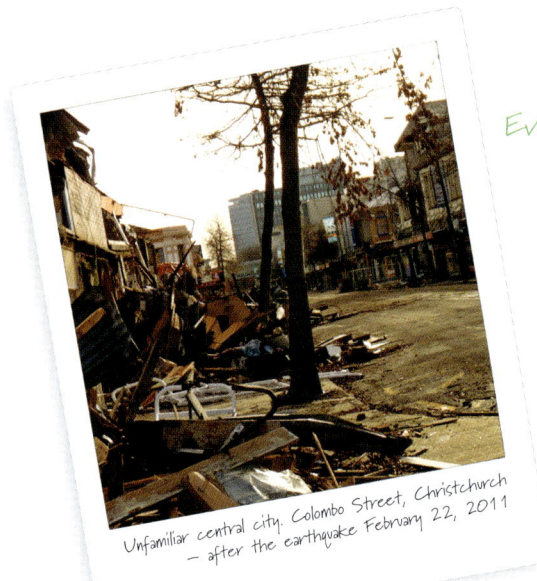

Unfamiliar central city. Colombo Street, Christchurch — after the earthquake February 22, 2011

Every adversity, every failure, and every heartache, carries with it the seed of an equivalent or greater benefit.

— Napoleon Hill

Staying Grateful # 2; Crisis Brings Opportunity

It's easy to appreciate the successes, achievements and the happy coincidences that come our way. But you don't need to wait for sunshine and smiles to practise gratitude.

Gratitude can turn a negative into a positive. Find a way to be thankful for your troubles and they can become your blessings (unknown)

Get comfortable with being uncomfortable for a moment. Contemplate the tough times you've come though, the difficulties encountered and the mistakes made. When you've leapt before looking, said the wrong thing, shown poor judgement, or forgotten something important.

Not to relive the challenges but to reframe them to gain a new perspective, ask yourself questions such as: What lessons did the experience teach me? Even though I wasn't thankful for what happened at the time, is there something about it I can be grateful for now looking back?

All our frustrating, boring, embarrassing, irritating times are opportunities to grow. They give us the chance to practise patience, honesty, loyalty, integrity, resilience, and self discipline.

The Chinese use two brush strokes to write the word 'crisis'. One brush stroke stands for danger; the other for opportunity. Be aware of the danger but recognize the opportunity

— John F. Kennedy

Green door in a green wall – Portimao, Portugal

> RED IS THE MOST JOYFUL AND DREADFUL THING IN THE PHYSICAL UNIVERSE. IT IS THE FIERCEST NOTE, IT IS THE HIGHEST LIGHT. IT IS THE PLACE WHERE THE WALL OF THIS WORLD OF OURS WEARS THINNEST AND SOMETHING BEYOND BURNS THROUGH
> — G K Chesterton

rED
ETERNAL

Red is arresting and stimulating, it's energising and sexy. A bland day can be jump-started with a jolt of red; you can eat it up with fresh strawberries or hot chilli; or paint it on with lipstick or nail-polish.

The smell of red is a spicy mulled wine by a winter's open fire – the air fragrant with woodsmoke dancing with notes of cinnamon and cardamom.

Red-painted eggs – Stari Grad, Dubrovnik

Staying Grateful # 3; Come to your Senses

Gratitude can begin with five things we often take for granted; our senses of smell, sight, touch, taste, and hearing.

Lose your mind and come to your senses
— Frederick S. Perls

Pick a sense. Let's start with smell. Ponder some of your favourite ways to experience it. For me favourite smells are Christmas Lillies in December, wind-dried laundry, fresh coffee, basil leaves bruised between my fingers, wood-smoke from autumn bonfires, and the smell of a freshly picked tomato, just near the stalk. Imagine losing your sense of smell – what scents would you miss the most?

These delights are little grace-filled moments and each one a chance to feel grateful. Celebrate each of your senses – even if some of them have diminished over time. Enjoy and be grateful for what you do have.

What about creating a *Riot of the Senses* week! I did this with the children one holidays, each day we focused on one sense and completely immersed ourselves in it. Imagine a whole day of Touch; walking barefoot, massage, hugs, petshop pats, and a beachside wander. Plan a day of Taste to include a visit to your local famers' market - try a little of each of your favourite things as well as the new and unusual; delight in the vibrant freshness and colours, and the love that has gone into all the creations.

Every day we should hear at least one little song, read one good poem, see one exquisite picture, and if possible, speak a few sensible words
— Goethe

Italian espresso
— Florence, Italy, 2008

Silence — St Catalina Monastery, Arequipa, Peru

Thanksgiving is possible only for those who
take time to remember
no one who has a short memory can give thanks

[anonymous]

Powder power — Nadi Market, Fiji

It isn't what you have in your pocket that makes you **thankful** but what you have in your **heart**

Amour in the Alps — Courchevel, France

Thank you for staying

Like babies in a great dark womb
— we curl inward just to stay alive.

It gets hotter and harder to breathe.
My heartbeat sounds closer — coming
from somewhere between brain and throat it
thuds dangerously in my ears.
So hot, so very hot.

Each breath sears a pathway inward. I try to suck the air in through my fingers to take the singe off it. I wonder if my hair might catch fire. As the incantations rise with the climbing temperature — we sit in the hot darkness, just breathing.
Just. And sweating. A lot.

I hear you whisper "Oh God!" under your breath.
It is so unbearable.
But you stay.

Thank you note #88; still friends after the sweat-lodge

Before the sweat-lodge
— Lake Wakatipu, Queenstown 2004

It's going to be H-O-T. It's going to be INtense. What are we getting ourselves into?

St Catalina Monastery — Arequipa, Peru

He is a wise man who does not grieve
for the things which he has not,
but rejoices for those which he has

— Epictetus

Red Vespa — Taormina, Sicily, Italy

Everyone gets
1,440 minutes each day

Spend at least one of them saying thanks

Fun at Fiorella Gallery — Venice, Italy

Be thankful for the difficult times
During those times you grow

Be thankful for your limitations
They give you opportunities for improvement

Be thankful for each new challenge
Know it will build your strength and character

Be thankful for your mistakes
They teach you valuable lessons

It is easy to be thankful for the good things
A life of rich fulfillment comes to those
who are also thankful for the setbacks

[unknown]

Flowers for my felt hat — Agua Calientes, Peru

Now may every living thing, young or old, weak or strong, living near or far, known or unknown, living or departed or yet unborn, may every living thing

be full of bliss

— Buddha

Mandala — Indian temple, Little India, Singapore

A picture painted in YELLOW
always radiates spiritual warmth
— Wassily Kandinsky

> What a horrible thing yellow is
> — Edgar Degas

Yellow on yellow — Cartagena, Colombia

YELLOW
IDYLLIC

Yellow is the colour of early summer optimism and carefree creativity. It's warm and buttery like corncobs and bursting with the golden intensity of sunflowers.

Passing our hive on a busy day I catch a warm waft of beeswax and honey — a smiling sense of yellow fills me from the inside out.

Other-worldly-landscape or a car door at Horopito Motors — Ohakune, NZ 2011

Danger — Horopito Motors

Landscape on the boot of an old Zephyr — Horopito Motors

Thank you for seeing

Weeds grow up through the bumpers.
Moss creeps across the bonnet.
It seems the old car is becoming something else,
something earthly and organic

As I look through the lens,
other worlds of colour and texture open.
Time suspends, breath is held,
light dances.

The car's peeling paint, rust patterns
and mossy outcrops become
an underwater landscape,
or a piece of exotic fabric.

Thank you note #101;
to my eyes

60

Hotel Santa Marina — Venice, Italy

When you arise in the morning
Give thanks for the morning light.
Give thanks for your life and strength.
Give thanks for your food
And give thanks for the joy of living.
And if perchance you see no reason for giving thanks,
Rest assured the fault is in yourself.

[American Indian saying]

Petal mandala — Little India, Singapore

Staying Grateful # 4; Mind your Language

The way we think about and describe the events in our lives creates a flavour or a thinking style through which we come to view the world. What do you think about your body and your health? Your job? How do you describe your children, your partner, your friends? Ungrateful people tend to focus on regrets, loss, need and what they don't have. Grateful people on the other hand tend to use words like blessed, fortunate, gifts, and abundance in their conversation. The good news is that it is easy to become more grateful.

To get started, become aware of two conversations:
1) Be aware of the things you say to yourself, i.e. your internal dialogue
 - What are you saying to yourself all day?
 - What are you thinking about?

2) Be aware of the things you say to the world, i.e. your external dialogue
 - What is your tone of voice? Do you sound like a glass-half-full optimist or a glass-half-empty pessimist?
 - What words do you use? Do you curse or swear? Do you moan or sigh?
 - What is the content of your conversation? Eleanor Roosevelt said; 'Great minds discuss ideas. Average minds discuss events. Small minds discuss people', What are you talking about?

Become your own silent observer. Listen to your inner and outer dialogues throughout each day. As your awareness increases you can make different choices.

If you realised how powerful your thoughts are you would NEVER think a negative thought
– Peace Pilgrim

Yellow ribbons of hope. Kia kaha Christchurch – Cathedral Square 2012

Ceremonial stands — Ubud, Bali

When you arise in the morning, think of what a precious privilege it is to be alive, to breathe, to think, to enjoy, to love

— Marcus Aurelius

Banana crisps — Cartagena, Colombia

Thank you for the world so sweet,
Thank you for the food we eat,
Thank you for the birds that sing,
Thank you God for everything.

[traditional children's prayer]

Hindu princesses in festival dress — Ubud, Bali

None is more impoverished than the one who has no gratitude. Gratitude is a currency that we can mint for ourselves, and spend without fear of bankruptcy.

— Fred De Witt Van Amburgh

Lemon peeling — Aguas Calientes, Peru

How far that little candle throws his beams!
So shines a good deed in a weary world
—William Shakespeare

Morning offerings — Kuta, Bali

Blue is the colour everlastingly appointed by the diety to be a source of delight

— John Ruskin

BLUE
AWE-INSPIRING

Blue is as endless as the ocean, as vast as the sky. Like a tiny boat we float in a dream between two blue worlds.

Blue is most people's favourite colour by far — maybe that is why we have so many names for its varied hues and moods.

Beehives — en route to Ruatoria, New Zealand

Staying Grateful # 5: Write a thank you letter

Too often we leave it too late to tell the people we love how much we appreciate them. We sometimes assume that the other person knows how we feel without us having to say anything. Even if they do know how we feel – it's still important to say it, or write it to them. The simple act of writing a thank you letter takes our thoughts and feelings from the mental and emotional level and grounds them in the physical dimension. It makes them real.

Get in the habit of reflecting a thank you to people who have done something to help you or shown you some kindness; your neighbour, your parents, your children, your friends, even your doctor. You could create a weekly or monthly ritual around thank you cards and letters – where you sit down, review your week and send out ten cards. If you have children, involve them in the process in a fun and creative way.

Write a thank you note or send a thank you card to someone for something today:
- Be specific about the action or contribution you want to praise
- Tell them of the impact of their actions in your life

Appreciation can make a day, even change a life. Your willingness to put it into words is all that is necessary
— Margaret Cousins

What about an *appreciation rampage* where the whole focus is on gratitude! I did this on my birthday one year. I shifted from 'What would I like to receive for my birthday?' to 'What would I like to give for my birthday?'. What I really wanted was for the people in my life to know how much I loved and appreciated them. I organised some beautiful bouquets of flowers, some wrapped in newspaper, some in fruit tins, some in jam jars – I loaded up the car and played 'floral express' for a day. I dropped in on friends and family unannounced, hunted people down I hadn't seen in a while and spent a brief moment of connection with them that lingers with me to this day.

Silent gratitude isn't much use to anyone
— Gladys Bronwyn Stern

Little woman passing a blue wall — Cartagena, Colombia

Take as a gift whatever the day brings forth

— Horace

This way to Heaven — Naoussa, Paros, Greece

Thank you for loving

You don't love me the way I love you
Your love is organic, expansive,
all-inclusive and uncontained
It is ancient and sacred
like a hieraglyph inside a pyramid
(I can read it by touch)

It is sheltering and protective
It is strong and sexy
It is patient and kind
(It's sometimes annoying too)

Thank you note #344;
to my soulmate, love & best-friend

My song wall; you wrote me, you sang me, you painted for me — Charleston, Westcoast, NZ

80

Undomed Buddha — Borobudur, Java

Give thanks for a little and you will find a lot

[Nigerian proverb]

Holy smoke – Borobudur, Java

Appreciation
is a wonderful thing
It makes what is excellent in
others belong to us as well

—Voltaire

Blanket stitch — Lake Titicaca, Peru

You say grace before meals. All right. But I say grace before the concert and the opera, and grace before the play and pantomime, and grace before I open a book, and grace before sketching, painting, swimming, fencing, boxing, walking, playing, dancing and grace before I dip the pen in the ink.

— G. K. Chesterton

Blue gondolas in the waking of a new day — Venice, Italy

We are so often caught up in our destination

that we forget to appreciate the journey,

especially the goodness

of the people we meet on the way.

[anonymous]

Blue moment — Hindu festival, Ubud, Bali

ORANGE is the HAPPIEST COLOUR

— Frank Sinatra

Orange
DELICIOUS

As I sink into the colour orange I feel like an ant inside a tiger-lily. Its heat warms me, its optimism inspires. I am transported across burnt sand deserts and over the terracotta roof tops of Stari Grad. I feel my edges start to singe and glow with the coming fires of transformation.

Spice it up — Garanada, Spain

You have no cause for anything but gratitude & joy

— Buddha

Peace prayers — Seminyak, Bali

Blessed are those that can give without remembering
and receive without forgetting

Unknown

Offering thanks – Legian, Bali

Give thanks
for unknown blessings
Already on their way

[unknown]

Bless this food — Legian, Bali

Thank you baby

Before you were born
your tiny molecules made constellations
within you, within me
Features forming, limbs budding
You came across the universe
Dancing between worlds
Meeting me in my dreams
And when at last you were born
there was just one word:
THANK YOU
Thank you for coming
I'm so glad you're here

thank you note #678;
to my sweet baby

© Shar Devine 2003
Satori holding my beautiful babyful tummy

Tobacco picker — Borobudur, Java

A thankful heart is not only the greatest virtue but the parent of all other virtues — Cicero

Marigold blessings — Kumbasari Market, Bali

Staying Grateful # 6; Count Your Heroes

Who inspires you? Movie stars that have swept you away on the big screen? Sports-greats who have inspired you with their skill and courage? Political leaders in history or in the news, or military leaders full of strategic brilliance and bravery? What of our great spiritual leaders through the ages; the heart-centred teachers and deep-thinking philosophers? You could choose from business leaders, scientists, inventors, writers, artists, musicians and explorers. The list of brilliant people that have gone before us is endless and the legacies they have left the world surround us in gifts. Who do you appreciate and admire? It may be someone famous, or it may be someone close to you like a parent or teacher who had a positive impact in your life.

It is not what we do, but how much love we put into the doing
— Mother Theresa

Rather than just think about our heroes - let's go one step further and create a personal advisory board of these inspirational people. Our very own tailor-made team that we can tune in to and imagine what advice or encouragement they would offer as we meet life's obstacles, opportunities and cross-roads. Who would you have? For a fitness coach? Business mentor? Fashion advisor? Start thinking, get googling, do some research. Find pictures of these people and create a scrapbook page of their portraits for your wall. Read their autobiographies and become familiar with their values and philosophy. Whenever you need some advice or a different perspective – ask yourself what they would say or do in this instance?

Simplicity is the ultimate sophistication
— Leonardo da Vinci

Wondering moment — Hindu Festival, Bali

Let a moment of gratitude blossom in your day

Its fragrance can fill your whole world

Offerings — Kumbasari Market, Bali

> FORGIVENESS
> IS THE FRAGRANCE
> THAT THE VIOLET
> SHEDS ON THE HEEL
> THAT HAS CRUSHED IT
> — Mark Twain

ENIGMATIC PURPLE

Magical majestic purple. Imbued with the sacred mystery of spirit and exuding a presence like royalty.

Purple is grape-stained feet, and combed lines of lavender. The smell of incense spirals me inward on shadowy wings to great temples of wonder.

A stranger's blueberry pie — La Soucoupe, Courchevel, France

If you haven't got all the things you want…
Be grateful for things you don't have that you don't want

[unknown]

Fragrant lines of lavender — Provence, France

thank you for the following, in no particular order:

- *Your wide-eyed optimism and belief that life is a grand adventure. It always will be*

- Being endlessly and ceaselessly creative; spinning, knitting, writing, photography, crochet, weaving, painting, drawing, glueing, hammering, sculpting, beachcombing, collecting, ripping and wrecking with complete abandon — through these explorations you'll find what you truly love and who you truly are

- *Being bold with your baking — fudge, coconut ice, hokey-pokey. From these carefree, sugar-loaded beginnings you are learning to cook*

- Feeding the wild birds wherever you go. Your intrepid adventures began with ducks and seagulls - but will lead to feeding fish-heads to wild pelicans in Ecuador, and getting caught feeding chips to giant gulls from the top deck of a ship in Alaska.

- *Making friends with Susan: you girls will be best friends for life*

- Deciding you wanted to ski deep powder like they did in the old Warren Miller movies. Thank you for sticking it out through car-high avalanches and rope tows that burned holes in mittens. So completely worth it.

just be yourself, trust yourself, and do what feeds your soul. You are going to grow up just fine.

thank you note #855; to younger me — about 8yrs

My whole day is smile-ful — Hindu Festival, Bali

Staying Grateful # 7; Take a Photo a Day

Take a photograph of something you appreciate everyday for a month - or even better, for a whole year. When I travel I slip into the role of curious observer with liquid ease. Maybe it's because I always have a camera with me and because of that I pay more attention to the little wonders happening in the world around me. A cup of coffee can be a visual delight - a memory to be savoured long after the smells and tastes of the moment have faded.

When we pay attention to the moments that surround us in our everyday lives - our 'everyday' loses its 'ordinary' feel. When we seek out the things we love within our routines - we live more consciously. Keep your camera with you as you travel through your day looking for moments to appreciate; your toenails after a pedicure, favourite objects around the home, the book you are reading. Once you get started you may find it hard to limit yourself to just one a day. Savour the people, places and things that make your life unique.

I am going to do this too - you can follow my progress on pinterest.com/thecreatrice (or follow the link from www.thecreatrix.co.nz). Start your own scrapbook or photo album and share it back.

Photography helps people to see
— Berenice Abbott

Lost among the herbs & spices — Granada, Spain

Gratitude is heaven itself

— William Blake

Violet garlic in school-girl plaits — Carcasonne, France

BEGIN with YOURSELF
AND SEEK WITHIN

Sacred SILVER + Sublime GOLD

Gold and silver; above and below. The radiant masculine and the resonant feminine. They spiral together in a sacred dance of ecstatic alchemy

Golden bells – Legian, Bali

Staying Grateful # 8: Pay it Forward

So often it is the smallest gestures that make the world a warmer, kinder, nicer place to live

Give back the goodness. Be willing to do a random act of kindness for a stranger when the moment presents itself. Once we are open to performing a good deed, we go about our day in a heightened state of awareness - more tuned in to the people and events happening around us, ready to lend a hand or show some kindness.

If you need a little inspiration:
- Read the book or watch the movie '*Pay it Forward*'
- Visit the Random Acts of Kindness Foundation online and get inspired to do something. They have lots of grabable ideas, uplifting stories, and helpful resources and links to get you started.
- Be on the lookout to try one of these ideas today: be the first to offer a smile, pay a compliment, show courtesy when driving, bake something for a neighbour (at work or at home), share something from your garden, leave a tip, pay the bill for the person behind you (as well as yourself), donate blood! Hold a door or lift, buy something from a child's street-side stall.

Cool italians on hot bikes — Taormina, Sicily 2006

Carry out a random act of kindness, with no expectation of reward, safe in the knowledge that one day someone may do the same for you

— Princess Diana

Vinegars in juicy hues — Saint-Rémy-de-Provence, France

Gratitude is the memory of the Heart

— Jean Baptiste Massieu

Holy water — Mother Temple of Besakih, Bali

At times our own light goes out and is rekindled by a spark
from another person. Each of us has cause to think
with deep gratitude of those who have
lighted the flame within us

—Albert Schweitzer

Remembering — Navossa, Paros, Greece

thanks a moment

I am not a morning person. The new day usually arrives without me.

Before I even open my eyes I have to run through a list of incentives to entice me out of bed; it's a beautiful day, there might be a parcel in the post, a coffee in the making....

Unfortunately, one negative thought (it's raining, it's cold, I've already slept in so long and wasted half the day, the pile of laundry) is enough to wipe out all previous positive thoughts.

Sigh. Maybe a hot shower? I'm still lying here — eyes shut — hoping the perfect espresso will miraculously appear.

Dreamy thoughts of being a lotus eater, a hammock dweller in a Maldivian paradise… Horrid thoughts of expired car registration,..

Pointless escapisim into being long-legged, lithe, and lean where I bounce out of bed every morning in a fever of excitement at my extensive [and tiny] wardrobe and what to wear because it all fits perfectly and looks fab. Folorn self-loathing at thought of my tracksuit pants once used for actual work-outs.

I definitely don't want to get up now.

What about a few more pages of my novel to gently nudge me into the new day. Can't see without squinting since perfect vision would require me to get up and put my contacts in. Cant face the mirror yet. Still hoping an espresso will be brought to me.

I read half a page then hear a Scream! and raised voices coming from the kitchen.

Between Bruges & Amsterdam

Siena, Italy

Florence, Italy

Aups, France

What is that noise? It's practically the middle of the night! Where's my COFFEE!

Guilt. If I had been in the kitchen all untimely mishaps would have been avoided and children would have manners of royalty. Lie there imagining a variety of industrial scale accidents taking place at the other end of the house.

If I don't get up I could be caught half-naked, unable to see and looking like death when the circus moves down hallway to bedroom. Decide I cant possibly recreate dreamy island idyll because serenity shattered, and can't read book due to potential fatalities in kitchen and ensuing guilt

OK I am getting up. Too Late. The bedroom door bangs open and slams back against the wall. Three sobbing children stagger in yelling, pointing, blaming... None of them has an espresso for me. I can only make out blurred frowns and weepy eyes. But...I suddenly smell something.....coffee?

I manage to haul myself into a sitting position while curtains are screeched open. Blinding! And a small cup of love is positioned in my hand. The children are bundled back out the door — closed quietly.

And I start the day with a smile on my face. Aaahh THANK YOU

thank you note #933; thanks for the coffee, my cup of love

Courchevel 1850, France

Bruges, Belgium

Let us rise up and be thankful
for if we didn't learn a lot today
at least we learned a little
and if we didn't learn a little
at least we didn't get sick
and if we got sick
at least we didn't die
so, let us all be thankful

—Buddha

Temple roof top through golden lace – Chiangmai, Thailand

The THANKYOU PROJECT

Thank you was my third thought as I lay sprawled on the floor with the Cathedral crashing down outside the window. My first thought was something like "Earthquake! BIG! Get-under-a-table!" My second thought was "Just hold on, the walls are peeling off, the floor is bucking, the roof is coming down, it's so loud, so violent, just hold on, just breathe!' Third thought was 'Thank you!' The old brick post office-come-café was still holding as the years were shaken out of her. There was so much dust in the air it was hard to see beyond the immediate room. I was so thankful to be alive and uninjured – it seemed miraculous.

Over the coming weeks and months I noticed how the kindness of strangers had become a new currency here in Christchurch, New Zealand. While weaving through jagged roads and orange cones, or wobbly supermarket aisles, one small gesture of kindness could curve my whole day into a smile. A new sense of purpose took root; I wanted to do something that would not only maintain the sense of community that was so strong when our city was at its weakest, but to build on it.

I have always loved a quote by 15th century monk Meister Eckhart, who said: "If you say one prayer your whole life, 'thank you' will suffice".

An idea sparked. Based on the idea that 'thank you is enough' I decided to *join the world in gratitude*. I created a simple but powerful process to encourage people to connect with a thank you. The Thankyou Project was born. I designed and printed thank you cards and began giving them away via hair salons, libraries, cafes and dentists – encouraging people to pick up a card and write a thank you to someone - while they had a few minutes. We continue to give away thousands of thank you cards - knowing that each one sent weaves another thread of kindness into our world, little by little making it a kinder place for all of us to live.

Profits from this book fund ongoing Thankyou Projects and help get new initiatives up and running. Have a look at our website to see some of the projects, processes and products we are excited about. If you would like to get involved: kind words, donations, distribution - it's easy, visit www.thankyouproject.co.nz

in thanks, Melanie

RESOURCES

My journey into *Thank you* is just beginning. The thoughts expressed in this book are my own opinions based on what I've read and discovered, and what I have learned through experience. My apologies for any oversights or omissions, if you kindly bring them to my attention they can be rectified in subsequent printings

Read
- Thanks! How Practicing Gratitude Can Make You Happier, by Robert Emmons, PH.D © 2007
- The Psychology of Gratitude, by Emmons & McCullough © 2004
- Count Your Blessings The Healing Power of Gratitude and Love, by Dr. John F. DeMartini © 1997
- Living in Gratitude, by Angeles Arrien © 2011
- Gratitude - A Way of Life, by Louise L.Hay & Friends © 1996 The Hay Foundation
- Gratitude Factor, The: Enhancing Your Life through Grateful Living, by Charles M. Shelton PhD © 2010
- Living Life as a Thank You: The Transformative Power of Daily Gratitude, by Lesowitz & Sammons © 2009
- Thank You Power: Making the Science of Gratitude Work for You, by Deborah Norville © 2008
- Gratefulness, The Heart of Prayer: An Approach to Life in Fullness, by Steindl-Rast & Nouwen © 1984

Listen
- Thank you, by Dido
 © 2000 Dido Armstrong
- Thank you for Being A Friend, by Andrew Gold
 © 1978 Andrew Gold
- Thank you, by Led Zep
 © 1969 Plant & Page
- Thank you for Hearing Me, by Sinead O'Connor
 © 1994 O'Connor & Reynolds
- Thank you, by MKTO
 © 2012 Bogart, Goldstein, Oller, Kelley, Kiriakou
- Thank you, by Alanis Morrissette
 © 1998 Morrisette & Ballard

Visit
- Thanksgiving Square; Dallas, Texas, USA. Worth it for the beautiful spiral stained glass windows alone
- The Gratitude Cafes; Enjoy 'sacred commerce' at one of their 4 cafes in California
- Merci; the famous charity concept-store in the heart of Paris

Surf
- psychology.ucdavis.edu/Labs/emmons
- www.randomactsofkindness.org
- kindnessfoundation.com
- greatergood.berkeley.edu/topic/gratitude
- www.gratefulness.org
- thxthxthx.com
- 365grateful.com
- www.templeton.org/grateful

Practise
- Count your blessings
- Keep a gratitude journal
- If in crisis, look for the opportunity
- Use all your senses
- Mind your language
- Write thank you letters
- Count your heroes
- Take a photo a day
- Pay it forward

PERMISSIONS

Thank you to the poets, writers, singers and songwriters whose work inspires me… May the creative spark in all of us be nurtured and encouraged to be fully, freely, and passionately expressed.

Particular acknowledgement to Shar Devine for permission to use her photograph of me on page 98.

GRATITUDE

I will be forever thankful
for the people
who fill my life with
blessings, learnings,
and opportunities to deepen
my understanding.

Now, more than ever
I am grateful for
my other support team,
the non-visible ones:
my angels, guides, guardians
and teachers, my constant
travelling companions.

We meet in silence
each day, across fragrant
candles, on wisps
of incense, between
the throaty notes
of didjeridoos and
the hearty beat
of goatskin drums.

As I journey inward
great worlds within
worlds expand in patterns
of geometric beauty.
Lifetimes of learning
coded into kaleidoscopes
of shape and colour.

Thank you for the love
and learning —
ever deepening,
ever expanding.

Blue hand of peace — Statue of Ganesha, Kuta, Bali